Paul Klee

Creative
Confession
and other
writings

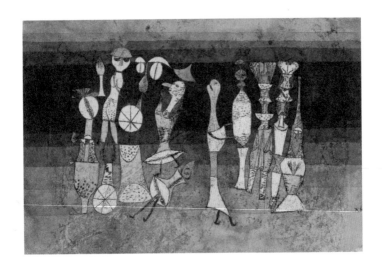

Paul Klee, *Comedy* 1921

Paul Klee

Creative Confession and other writings

Tate Publishing

First published 2013 by order of the Tate Trustees
by Tate Publishing, a division of Tate Enterprises Ltd,
Millbank, London SW1P 4RG
www.tate.org.uk/publishing

A catalogue record for this book is available from the British Library
ISBN 978 1 84976 234 2
Distributed in the United States and Canada by ABRAMS, New York
Library of Congress Control Number applied for

Designed by Inventory Studio London
Colour reproduction by DL Imaging, London
Printed in the UK by T J International

Front cover: Paul Klee, *Ghost of a Genius* 1922
Frontispiece: Paul Klee, *Comedy* 1921

ebook also available

Contents

Creative Confession, 1920[1]

I

Art does not reproduce the visible; rather, it makes visible. A tendency towards the abstract is inherent in linear expression: graphic imagery being confined to outlines has a fairytale quality and at the same time can achieve great precision. The purer the graphic work – that is, the more the formal elements underlying linear expression are emphasised – the less adequate it is for the realistic representation of visible things.

The formal elements of graphic art are dot, line, plane, and space – the last three charged with energy of various kinds. A simple plane, for instance – that is, a plane not made up of more elementary units – would result if I were to draw a blunt crayon across the paper, thus transferring an energy-charge with or without modulations. An example of a spatial element would be a cloud-like vaporous spot, usually of varying intensity, made with a full brush.

II

Let us develop this idea, let us take a little trip into the land of deeper insight, following a topographic plan. The dead centre being the point, our first dynamic act will be the line. After a short time, we shall stop to catch our breath (the broken line, or the line articulated by several stops). I look back to see how far we have come (counter-movement). Ponder the distances thus far travelled (sheaf of lines). A river may obstruct our progress: we use a boat (wavy line). Further on there might be a bridge (series of curves).

On the other bank we encounter someone who, like us, wishes to deepen his insight. At first we joyfully travel together (convergence), but gradually differences arise (two lines drawn independently of each other). Each party shows some excitement (expression, dynamism, emotional quality of the line).

We cross an unploughed field (a plane traversed by lines), then thick woods. One of us loses his way, explores, and on one occasion even goes through the motions of a hound following a scent.

Nor am I entirely sure of myself: there is another river, and fog rises above it (spatial element). But then the view is clear again.

Basket-weavers return home with their cart (the wheel). Among them is a child with bright curls (corkscrew movement). Later it becomes sultry and dark (spatial element). There is a flash of lightning on the horizon (zigzag line), though we can still see stars overhead (scattered dots).

Soon we reach our first quarters. Before falling asleep, we recall a number of things, for even so short a trip has left many impressions.

Lines of the most various kinds, spots, dabs, smooth planes, dotted planes, lined planes, wavy lines, obstructed and articulated movement, counter-movement, plaitings, weavings, bricklike elements, scale-like elements, simple and polyphonic motifs, lines that fade and lines that gain strength (dynamism).

The joyful harmony of the first stretch, followed by inhibitions, nervousness! Repressed anxieties, alternating with moments of optimism caused by a breath of air. Before the storm, sudden assault by horseflies! The fury, the killing.

The happy ending serves as a guiding thread even in the dark woods. The flashes of lightning made us think of a fever chart, of a sick child ... long ago.

III

I have mentioned the elements of linear expression which are among the visual components of the picture. This does not mean that a given work must

consist of nothing but such elements. Rather, the elements must produce forms, but without being sacrificed in the process. They should be preserved.

In most cases, a combination of several elements will be required to pro-duce forms or objects or other compounds – planes related to each other (for instance, the view of a moving stream of water) or spatial structures arising from energy-charges involving the three dimensions (fish swimming in all directions).

Through such enrichment of the formal symphony the possibilities of varia-tion, and by the same token, the possibilities for expressing ideas, are end-lessly multiplied.

It may be true that 'in the beginning there was the deed', yet the idea comes first. Since infinity has no definite beginning, but like a circle may begin any-where, the idea may be regarded as primary. 'In the beginning was the word', according to Luther's translation.

IV

Movement is the source of all change. In Lessing's *Laocoön*, on which we squandered study time when we were young, much fuss is made about the difference between temporal and spatial art. Yet looking into the matter more closely, we find that all this is but a scholastic delusion. For space, too, is a temporal concept.

When a dot begins to move and becomes a line, this requires time. Likewise, when a moving line produces a plane, and when moving planes produces spaces.|

Does a pictorial work come into being at one stroke? No, it is constructed bit by bit, just like a house.

And the beholder, is he through with the work at one glance? (Unfortunately he often is.)

Does not Feuerbach say somewhere that in order to understand a picture one must have a chair? Why the chair?

So that your tired legs won't distract your mind. Legs tire after prolonged standing. Hence, time is needed.

Character, too, is movement. Only the dead point as such is timeless.

In the universe, too, movement is the basic datum. (What causes movement? This is an idle question, rooted in error.) On this earth, repose is caused by an accidental obstruction in the movement of matter. It is an error to regard such a stoppage as primary.

The Biblical story of Genesis is an excellent parable of movement. The work of art, too, is above all a process of creation, it is never experienced as a mere product.

A certain fire, an impulse to create, is kindled, is transmitted through the hand, leaps to the canvas, and in the form of a spark leaps back to its starting place, completing the circle – back to the eye and further (back to the source of the movement, the will, the idea).

The beholder's activity, too, is essentially temporal. The eye is made in such a way that it focuses on each part of the picture in turn; and to view a new section, it must leave the one just seen.

Occasionally the beholder stops looking and goes away – the artist often does the same thing. If he thinks it worth while, he comes back – again like the artist.

The beholder's eye, which moves about like an animal grazing, follows paths prepared for it in the picture (in music, as everyone knows, there are conduits leading to the ear; the drama has both visual and auditive trails). The pictorial work was born of movement, is itself recorded movement, and is assimilated through movement (eye muscles).

V

Formerly we used to represent things which were visible on earth, things we either liked to look at or would have liked to see. Today we reveal the reality that is behind visible things, thus expressing the belief that the visible world is merely an isolated case in relation to the universe and that there are many more other, latent realities. Things appear to assume a broader and more diversified meaning, often seemingly contradicting the rational experience of yesterday. There is a striving to emphasise the essential character of the accidental.

By including the concepts of good and evil a moral sphere is created. Evil is not conceived as the enemy whose victories disgrace us, but as a force within the whole, a force that contributes to creation and evolution. The simultaneous existence of the masculine principle (evil, stimulating, passionate) and the feminine principle (good, growing, calm) result in a condition of ethical stability.

To this corresponds the simultaneous unification of forms, movement and counter-movement, or, to put it more naïvely, the unification of visual oppositions (in terms of colourism: use of contrasts of divided colour, as in Delaunay). Each energy calls for its complementary energy to achieve self-contained stability based on the play of energies. Out of abstract elements a formal cosmos is ultimately created independent of their groupings as concrete objects or abstract things such as numbers or letters, which we discover to be so closely similar to the Creation that a breath is sufficient to turn an expression of religious feelings, or religion, into reality.

VI

A few examples:

A sailor of antiquity in his boat, enjoying himself and appreciating the comfortable accommodation. Ancient art represents the subject accordingly.

And now: the experiences of a modern man, walking across the deck of a steamer:

1. His own movement, 2. the movement of the ship which could be in the opposite direction, 3. the direction and the speed of the current, 4. the rotation of the earth, 5. its orbit, and 6. the orbits of the stars and planets around it.

The result: an organisation of movements within the cosmos centred on the man on the steamer.

●

An apple tree in bloom, its roots and rising saps, its trunk, the cross section with the annual rings, the blossom, its structure, its sexual functions, the fruit, the core with its seeds.

An organisation of states of growth.

●

A man asleep, the circulation of his blood, the regular breathing of his lungs, the intricate functioning of his kidneys, and in his head a world of dreams, in contact with the powers of fate.

An organisation of functions, which taken together produce rest.

VII

Art is a simile of the Creation. Each work of art is an example, just as the terrestrial is an example of the cosmic.

The release of the elements, their grouping into complex subdivisions, the dismemberment of the object and its reconstruction into a whole, the pictorial polyphony, the achievement of stability through an equilibrium of movement, all these are difficult questions of form, crucial for formal wisdom, but not yet art in the highest circle. In the highest circle an ultimate mystery lurks behind the mystery, and the wretched light of the intellect is of no avail.

One may still speak reasonably of the salutary effects of art. We may say that fantasy, inspired by instinctual stimuli creates illusory states which somehow encourage or stimulate us more than the familiar natural or known supernatural states.

Its symbols bring comfort to the mind, by making it realise that it is not confined to earthly potentialities, however great they may become in the future; that ethical gravity holds sway side by side with impish laughter at doctors and parsons.

But, in the long run, even enhanced reality proves inadequate.

Art plays an *unknowing* game with ultimate things, and yet achieves them!

Cheer up! Value such country outings, which let you have a new point of view for once as well as a change of air, and transport you to a world which, by diverting you, strengthens you for the inevitable return to the greyness of the working day.

More than that, they help you to slough off your earthly skin, to fancy for a moment that you are God; to look forward to new holidays, when the soul goes to a banquet in order to nourish its starved nerves, and to fill its languishing blood vessels with new sap.

Let yourself be carried on the invigorating sea, on a broad river or an enchanting brook, such as that of the richly diversified, aphoristic graphic art.

Ways of Nature Study, 1923[2]

For the artist, dialogue with nature remains a *conditio sine qua non*. The artist is a man, himself nature and a part of nature in natural space.

But the ways that this man pursues both in his production and in the related study of nature may vary, both in number and in kind, according to his view of his own position in this natural space.

The ways often seem very new, though fundamentally they may not be new at all. Only their combination is new, or else they are really new in comparison with the number and character of yesterday's ways. But to be new as against yesterday is still revolutionary, even if it does not shake the immense old world. There is no need to disparage the joy of novelty; though a clear view of history should save us from desperately searching for novelty at the cost of naturalness.

●

Yesterday's artistic creed and the related study of nature consisted, it seems safe to say, in a painfully precise investigation of appearance. I and you, the artist and his object, sought to establish optical-physical relations across the invisible barrier between the 'I' and the 'you'. In this way excellent pictures were obtained of the object's surface filtered by the air; the art of optical sight was developed, while the art of contemplating unoptical impressions and representations and of making them visible was neglected.

Yet the investigation of appearance should not be underestimated; it ought merely to be amplified. Today this way does not meet our entire need any more than it did the day before yesterday. The artist of today is more than an improved camera; he is more complex, richer, and wider. He is a creature on the earth and a creature within the whole, that is to say, a creature on a star among stars. Accordingly, a sense of totality has gradually entered into the artist's con-

ception of the natural object, whether this object be plant, animal, or man, whether it be situated in the space of the house, the landscape, or the world, and the first consequence is that a more spatial conception of the object as such is born.

The object grows beyond its appearance through our knowledge of its inner being, through the knowledge that the thing is more than its outward aspect suggests. Man dissects the thing and visualises its inside with the help of plane sections; the character of the object is built up according to the number and kind of sections that are needed. This is visible penetration, to some extent that of a simple knife, to some extent helped by finer instruments which make the material structure or the material function clear to us.

The sum of such experience enables the 'I' to draw inferences about the inner object from the optical exterior, and, what is more, intuitive inferences. The optic-physical phenomenon produces feelings which can transform outward impression into functional penetration more or less elaborately, according to their direction. Anatomy becomes physiology.

But there are other ways of looking into the object which go still further, which lead to a humanisation of the object and create, between the 'I' and the object, a resonance surpassing all optical foundations. There is the non-optical way of intimate physical contact, earthbound, that reaches the eye of the artist from below, and there is the non-optical contact through the cosmic bond that descends from above. It must be emphasised that intensive study leads to experiences which concentrate and simplify the processes of which we have been speaking. For the sake of clarification I might add that the lower way leads through the realm of the static and produces static forms, while the upper way leads through the realm of the dynamic. Along the lower way, gravitating towards the centre of the earth, lie the problems of static equilibrium that may be characterised by the words: 'To stand despite all possibility of falling.' We are led to the upper ways by yearning to free ourselves from

earthly bonds; by swimming and flying, we free ourselves from constraint in pure mobility.

All ways meet in the eye and there, turned into form, lead to a synthesis of outward sight and inward vision. It is here that constructions are formed which, although deviating totally from the optical image of an object yet, from an overall point of view, do not contradict it.

●

Through the experience that he has gained in the different ways and translated into work, the student demonstrates the progress of his dialogue with the natural object. His growth in the vision and contemplation of nature enables him to rise towards a metaphysical view of the world and to form free abstract structures which surpass schematic intention and achieve a new naturalness, the naturalness of the work. Then he creates a work, or participates in the creation of works, that are the image of God's work.

Exact Experiments
in the Realm of Art, 1928[3]

We construct and keep on constructing, yet intuition is a good thing. You can do a good deal without it, but not everything. Where intuition is combined with exact research it speeds up the progress of research. Exactitude winged by intuition is at times best. But because exact research is exact research, it gets ahead even without intuition, though perhaps not very quickly. In principle it can do without intuition. It can be logical; it can construct. It can build bridges boldly from one thing to another. It can maintain order in the midst of turmoil.

In art, too, there is room enough for exact research, and the gates have been open now for quite some time. What was accomplished in music before the end of the eighteenth century has hardly been begun in the pictorial field. Mathematics and physics provide a lever in the form of rules to be observed or contradicted. They compel us – a salutary necessity – to concern ourselves first with the function and not with the finished form. Algebraic, geometrical, and mechanical problems are steps in our education towards the essential, towards the functional as opposed to the impressional. We learn to see what flows beneath, we learn the prehistory of the visible. We learn to dig deep and to lay bare. To explain, to analyse.

We learn to look down on formalism and to avoid taking over finished products. We learn the very special kind of progress that leads towards a critical striving backward, toward the earlier on which the later grows. We learn to get up early to familiarise ourselves with the course of history. We learn cogent truths on the way from causes to facts. We learn to digest. We learn to organise movement through logical relations. We learn logic. We learn organism. As a result the tension between us and the finished product eases. Nothing exaggerated – tension inside, behind, underneath. Passionate only deep within. Inwardness.

All this is fine but has its limits: intuition remains indispensable. We document, explain, justify, construct, organise: these are good things, but we do not succeed in coming to the whole. We have worked hard: but genius is not hard work, despite the proverb. Genius is not even partly hard work, as might be claimed on the grounds that geniuses have worked hard, in spite of their genius. Genius is genius, grace; it is without beginning and end. It is creation. Genius cannot be taught, because it is not a norm but an exception. It is hard to reckon with the unexpected. And yet as leader it is always far ahead. It bursts ahead in the same direction or in another direction. This very day, perhaps, it is already in a place we seldom think of. For from the standpoint of dogma, genius is often a heretic. It has no law other than itself.

The school had best keep quiet about genius; it had best keep a respectful distance. The school had best lock up the secret and guard it well. For if this secret were to emerge from latency, it might ask illogical and foolish questions.

It would stir up a revolution. Surprise and perplexity. Indignation and expulsion. Out with the total synthetist! Out with the totaliser! We are against! And the insults would fall like hail: Romanticism! Cosmicism! Mysticism! In the end we should have to call in a philosopher, a magician! Or the great dead (who are dead?). We should have to hold classes on holidays outside the school. Out under the trees, with the animals, by the side of brooks. Or on the mountains in the sea.

We should have to give assignments such as: construction of the secret. *Sancta ratio chaotica!* Scholastic and ridiculous. And yet that would be the assignment if construction accounted for everything.

But we may as well calm down: construction is not absolute. Our virtue is this: by cultivating the exact we have laid the foundations for a science of art, including the unknown X, making a virtue of necessity.

Postscript: Reflections on Klee's Early Writings
Matthew Gale

I

In the three texts published in this volume, we encounter the development of Paul Klee's thoughts on art as he expressed them in print during the 1920s. They are brief extrapolations of his thinking at any given moment, although it is likely (in some cases, evident) that each text was subject to careful revision and that the thinking had some cumulative value for Klee.

II

The first text, initially known as 'Graphic Art' but published as 'Creative Confession' (though habitually mis-translated as 'Creative Credo' in English),[4] is the best known of these short writings. It was commissioned in the late summer of 1918 by the writer Kasimir Edschmid (*nom-de-plume* of Eduard Schmid) for a compendium of such texts, but did not go to print until the end of the following year to reach publication in 1920.

It reflected an understandably tense period in European cultural life. Edschmid's project indicated that culture counted for something despite the terrible loss of life in the World War, that included the painter Franz Marc, Klee's friend, who was killed at the Front in March 1916. Prior to August 1914, the developments in contemporary art had been overwhelmingly associated with internationalism. By 1918, the nationalism on all sides appeared stifling and the powerful example of the Russian Revolution of late 1917 cast a warning light on the whole fabric of the society that had promulgated the conflict. The November 1918 Armistice and the Kaiser's abdication coincided with the eruption of communist revolution in Berlin and Munich, bringing a violent backlash.

To commission multiple articles on the aesthetic beliefs of contemporary artists was, therefore, to reflect on these complex times. More than simply opening the door onto the 'ivory towers' of artists, writers and composers, in a way that might suggest their isolation from the realities and hardships of the conflict, the series suggested a healing process.[5] A trace of trepidation at the post-war reckoning may be found in Klee's desire to establish an 'ethical stability' between good and evil.[6] Max Beckmann was more explicit in his contribution, predicting 'difficult times' in which 'we have to get as close to the people as possible. It is the only course of action which might give some purpose to our superfluous and selfish existence – that we give people a picture of their fate.'[7]

III

Edschmid's invitation to Klee on 30 August 1918 confirmed that the painter,[8] who had begun to find an audience during wartime through Herwarth Walden's Berlin gallery Der Sturm, was a name that the anticipated readership would recognise and find interesting. Within weeks he had completed a first draft of 'Graphic Art', as he then called it, although a polished version was not ready until November 1918.[9]

As this was to be his first published reflection on his own art, it is likely that he drew on ideas already noted in his diaries, such as the 1917 passage beginning 'Thoughts at the open window'.[10] There he observed: 'Everything we see is a proposal, a possibility, an expedient. The real truth, to begin with, remains invisible beneath the surface.' Reflecting on his own progress, he added: 'I had fought my way through formal problems. And now I no longer saw any abstract art. Only abstraction from the transitory remained. The world was my subject, even though it was not the visible world.' This reflects the sense of the relation between nature and abstraction that Klee attributed to his wartime development.

The retrospective voice here is bound up with Klee's practice of revising his writings, which was especially prevalent at this moment. The drafts of 'Creative Confession' in late 1918 were significantly revised during the extended delay that saw Edschmid's publication arrive only in early 1920, a delay which bolstered the critical attention around Klee's exhibition at Hans Goltz's Munich gallery that May. The propensity to revision was habitual. Around this time, Klee was privately polishing phrases in his diaries, excising immaturities and inserting retrospective observations that transformed the original – which he appears to have destroyed – into a literary rather than an eye-witness endeavour.[11] It is in this spirit that he answers his own question in 'Creative Confession' (part IV): 'Does a pictorial work come into being at one stroke? No, it is constructed bit by bit, just like a house.'

There is little doubt, therefore, that the changes that Klee made to the manuscript were part of a self-conscious awareness of the public importance of this text. Though on a more modest scale, it was equivalent to his friend Wassily Kandinsky's *Concerning the Spiritual in Art* that had appeared at the height of the pre-war explosion of avant-gardism in Munich.[12] In this way 'Creative Confession' laid out Klee's position on the triangular relationship between the artist, the response to nature and the artwork in ways that are at once straightforward and idiosyncratic.

Unlike Kandinsky's broadly sweeping vision of modern art, Klee's more modest field of action was 'graphic art', as indicated in the second sentence: 'A tendency towards the abstract is inherent in linear expression.'

This was both at Edschmid's request and broadly how Klee was seen at this period: as an artist primarily concerned with the graphic through draughtsmanship and printmaking. It is notable that he makes explicit the connection between the graphic and the abstract, thus opening up the discussion to the most pressing of aesthetic arguments around the engagement of avant-gardism both before and after the outbreak of the war.

When it came to be published as 'Creative Confession', this opening passage had been subjected to a further revision, whereby the initial opening takes second place and is superseded by the more programmatic: 'Art does not reproduce the visible; rather, it makes visible.' This new phrase would become one of Klee's most resonant. Such views were in the air, representing a condensation of the conjunction of abstraction and the transcendent that he shared with colleagues including the writer Theodor Däubler and Oskar Schlemmer, who had campaigned unsuccessfully for Klee's appointment to a teaching post at the Stuttgart Academy in the months before publication.[13]

The published text of 'Creative Confession' itself is clear but deliberately fragmentary. Its short sections build to a complex picture of Klee's understanding of the role of graphic arts in the period 1918–20. Above all the curious, allusive and perhaps slightly mystifying extended metaphor of the creative process as a journey (part II) gave the text the distinction of a wilful originality and individualism that most would associate with artists aspiring to an avant-garde status. The metaphor is a prelude to Klee's wider exposition of a theory in which abstract harmony and the role of genius interact. As well as citing Anselm Feuerbach – the German Romantic painter – he mentions Robert Delaunay, the Frenchman whose work he had so admired before the war that he translated one of his key texts for the Berlin periodical *Der Sturm*. This signalled an even-handed treatment of the national tradition and the internationalism of the modern.

Wrapped up in Klee's concern with genius – which readers are bound to divine as a status that he claimed (however modestly) for himself – is the longstanding identification of the artistic process with that of God's creation. Indeed, Klee cites God in two of these texts, equating creativity and Genesis. The artist (by which he also means himself) creates or is the conduit that makes the new. In part IV of 'Creative Confession' this is described as a 'certain fire ... transmitted through the hand, [that] leaps to the canvas, and ... leaps back to its starting place ... back to the eye and further'. An aware-

ness of Michelangelo's *Creation of Adam*, with its famous gap between the outstretched hands of Creator and created, may lurk behind this description of the circulating spark, and while Klee felt oppressed by the Sistine Chapel when he saw it as a student at the turn of the century it is clear from *The Creator* 1934 that memories of its imagery remained powerfully embedded as a narrative of creativity.[14]

IV

Although the imagery of creativity again underpins 'Ways of Nature Study' published in the *Staatlisches Bauhaus Weimar, 1919–23* catalogue in 1923, the final sentence surprisingly recalls Romantic views of the artist who 'participates in the creation of works, that are the image of God's work'. As the title of the text confirms, this conclusion is a resolution of that artistic endeavour with that of the natural world. In this respect, the phrase 'God's work' serves as shorthand for the complexity of nature but it remains a striking allusion with which to close the short text. Klee stops short of embracing the awe-stricken sublime but he explores his own detailed investigation of the complexities of nature as the source of his art.

Klee's position on the importance of observation in 'Ways of Nature Study' must be seen in the context of the Bauhaus for which it was written. He had been teaching in Weimar for two years by the time that the text was published, and he had already developed the teaching course that would form the substance of his lecture 'On Modern Art' in Jena in 1924 and his subsequent, and best-known, publication *Pedagogical Sketchbook* that was published in 1925. The readership for the 1923 essay was the student body whom he taught as well as those contemporaries who would concern themselves with understanding the view of modernism at the Bauhaus. At this moment, like so many others in its brief history, the school was in flux. Begun with the explicit undertaking to conjoin arts and crafts in a way that drew upon a wider upsurge in educational and cultural reform, the Bauhaus still, in 1923,

valued the traditions of observation about which Klee was writing. At the same time there was a growth towards functionalism which would, after the move of the Bauhaus to Dessau in 1925,[15] lead to the greater isolation of Klee and Kandinsky, as creative artists, from the other masters.

In these circumstances, Klee speaks up in 'Ways of Nature Study' for the persistence of observation, valuing the importance of understanding natural patterns in the creative processes to which the Bauhaus aspired.

V

The brevity of 'Ways of Nature Study' has the effect of making it a preamble to the texts that followed. Although Klee was aware of addressing a quite different audience for his lecture in Jena on 26 January 1924, which accompanied his exhibition at the Kunstverein, there are inevitable continuities. In Jena he used the simile of a tree, with the artist as the trunk between roots in the understanding of the world and a canopy that is his work. From this he declared: 'Nobody would affirm that the tree grows its crown in the image of its roots ... It is obvious that different functions expanding in different elements must produce vital divergences.'[16] For an audience confronted with the paintings this was an elegantly simple defence of artistic creativity. Just as with 'Creative Confession' he was also concerned with the processes of making, especially the potential and limitations of line (as 'measure'), tone (as 'weight') and colour ('quality').[17] It is from these elements Klee argued, that the artist works to establish the equilibrium within his composition because he 'places more value on the powers which do the forming than on the final forms themselves'.[18]

Klee's conclusion was that nature, and thus reality, was in a state of evolution. Extending the thread of investigation suggested in 'Ways of Nature Study' he declared of the artist: 'The deeper he looks, the more readily he can extend his view from the present to the past, the more deeply he is impressed by

the one essential image of creation itself, as Genesis, rather than the image of nature, the finished product.'[19] This evolutionary mode could gain a mildly political inflection as, in remarking on the 'unsettled times', Klee asserted: 'I do not wish to represent the man as he is, but only as he might be.'[20] At the end of the lecture he sought the understanding and support of his audience and – at a moment in which the future of the Bauhaus was in the balance – referred to the school as 'a community to which each one of us gave what he had. More we cannot do.'[21]

VI

If such a brief outline of the Jena lecture can suggest its shape, it is significant that it provided continuities with the ideas of 'Ways of Nature Study' and the more detailed consideration of the structures of composition that are analysed in the *Pedagogical Sketchbook*. Published in 1925 as the second of the *Bauhausbucher, Pedagogical Sketchbook* implicitly affirmed the need for community during the problematic period of the move to Dessau.[22] By far the best known of Klee's writings, it was completed in Weimar in 1924 as a distillation of his teaching practices to date. As such it lived up to its title in being primarily instructive in the way that it aligned theory with practice, a flavour supported by the use of short numbered sections illustrated by hand-drawn diagrams.

Taking up the metaphor used in 'Creative Confession', it famously starts: 'An active line on a walk, moving freely, without goal.'[23] This mixture of the didactic and the anthropomorphic remained characteristic. It returns in 'the father of the arrow is the thought',[24] and such poetic thinking proved a revelation of Klee's wider teaching practice.[25] This image produces a rare moment of existential reflection in the book, as he concludes: 'The contrast between man's capacity to move at random through material and metaphysical spaces and his physical limitations, is the origin of all human tragedy. It is this contrast between power and prostration that implies the duality of human existence. Half winged – half imprisoned, this is man!'

VII

By the time that Klee published 'Exact Experiments in the Realm of Art' in 1928 in another Bauhaus volume (*bauhaus, vierteljahrzeitschrift für gestaltung*),[26] there were further nuances to be explored. Here the functional evolution traced in *Pedagogical Sketchbook* appeared in need of renewed adjustment in favour of the role of intuition. Again Klee reviewed his manuscript and the changes show how the first draft was more direct, more anxious even, in its defence of intuition. As published Klee's second sentence read: 'You can do a good deal without it, but not everything.' However, the original had been explicitly more pointed in remarking: 'You can do a good deal without it, *but can awaken no true artistic life. To no work of art whose conception is significant.*'[27] This probably reflects Klee's natural inclination to polish texts, but the eventual restraint is significant in the light of the increasing productivism at the Bauhaus under Hannes Meyer, who, in April 1928, took over the directorship from Walter Gropius.

The alignment of art with craft that had underpinned the school under Walter Gropius was shifted significantly under Meyer in favour of the productive design now so readily associated with the Bauhaus. In his text, Klee stood out against this – or against a wholesale move – in making the case for intuition and genius as a balance to exactitude. The reader is (again) to understand Klee as the genius, but in the end, his irony rescued him from stridency. In suggesting that the school might have to 'keep quiet about genius', he dared to venture that classes might have to be held elsewhere: 'Out under the trees, with the animals, by the side of brooks. Or on the mountains in the sea.' This bucolic image reads like an echo of Klee's recent unofficial extension of his holiday on the Mediterranean islands of Porquerolles and Corsica from which he returned a fortnight late for teaching because he was committed to his painting.[28] Thus the text contains a circuitous self-justification of his engagement with nature.

VIII

Klee has a reputation for reticence and an almost lofty removal from the world which, however deeply embedded, is not precisely accurate. In 1930, for instance, the critic Ernö Kállai remarked on a 'visionary element' in the work of Klee and Kandinsky: 'It is not a romantic rapture over distant worlds … but is instead dominated by an awareness of the real presence of irrational elements pushing and germinating inside us, in our flesh and blood.'[29]

For all his own self-identification as an intuitive genius, Klee used these short texts, and the longer teaching notes from which *Pedagogical Sketchbook* was drawn, to try to draw a public (whether student or simply interested) into the dialogue that he was already having with the world around him through his art. Quoting from 'Creative Confession' in her introduction to *Pedagogical Sketchbook*, Sibyl Moholy-Nagy proposed: 'His forms are derived from nature, inspired by observation of shapes and cyclic change but their appearance only matters in so far as it symbolizes an inner actuality that receives meaning from its relationship to the cosmos.'[30] This mystical view of Klee, though rather modified over recent years, finds its source in his own words towards the end of 'Ways of Nature Study': 'We are led to the upper ways by yearning to free ourselves from earthly bonds; by swimming and flying, we free ourselves from constraint in pure mobility.'

References

[1] Kasimir Edschmid (ed.), *Shöpferische Konfession*, vol.13, *Tribune der Kunst und Zeit*, [Berlin] 1920, reprinted in Christian Geelhaar (ed.), *Paul Klee: Schriften; Rezensionen und Aufsätze*, Cologne 1976, pp.118-123; this (slightly modified) translation from *The Inward Vision: Watercolors, Drawings, Writings by Paul Klee*, trans. Norbert Guterman, New York 1959, pp.5–10.

[2] 'Wege des Naturstudiums', *Staatlisches Bauhaus Weimar, 1919–23*, Munich 1923, reprinted in Geelhaar 1976, pp.124–6; this translation in Jürg Spiller (ed.), *Paul Klee: The Thinking Eye; The Notebooks of Paul Klee*, vol.1, Basel 1956, trans. Ralph Manheim with Charlotte Weidler and Joyce Wittenborn, London and New York 1961, pp.63–7.

[3] 'exakte versuche im bereich der kunst', *bauhaus, vierteljahrzeitschrift für gestaltung*, vol.2, no.2, Dessau 1928, reprinted in Geelhaar 1976, pp.130–2; this translation in Spiller 1961, pp.69–70.

[4] Edschmid 1920. 'Confession' is preferred in Carola Giedion-Welcker, *Paul Klee*, London 1952, trans. Alexander Gode, pp.65–6, and O.K. Werckmeister, *The Making of Paul Klee's Career 1914–1920*, Chicago and London 1984, pp.131, 210–13, 259 n.22. The manuscript of the original 'Graphic Art' (Zentrum Paul Klee, Bern) was published in Geelhaar 1976, pp.171-4.

[5] The contributors were (in order of publication): René Schickele, Max Pechstein, Fritz von Unruh, Rudolf Grossmann, Paul Klee, Ernst Toller, Gottfried Benn, Bernhard Hoetger, Max Beckmann, Edwin Scharf, Johannes R Becher, Arnold Schönberg, Georg Kaiser, Conrad Felixmüller, Carl Sternheim, Adolf Hölzel, Franz Marc and Theodor Däubler.

[6] 'Creative Confession' part V; see Werckmeister 1984, pp.134–5.

[7] See Beckmann, 'Creative Credo', trans. in Victor H. Miesel, *Voices of German Expressionism*, London 1970, 2003, pp.107–9 [p.108]. For Pechstein's text see ibid. pp.180–1.

[8] Edschmid to Klee, 30 August 1918, cited in Werckmeister 1984, p.131.

[9] Klee to Lily Klee, 19 September and 5 November 1918, cited ibid. See facsimile of the manuscript and transcription as 'Graphik' in J. Glaesemer (ed.), *Paul Klee: Das graphische und plastische Werk*, Duisburg 1974 and Bern 1975, pp.6–17.

[10] *Tagebücher von Paul Klee 1898–1918*, ed. Felix Klee, Cologne 1957, as *The Diaries of Paul Klee, 1898–1918*, trans. Pierre B. Schneider, R.Y. Zachary and Max Knight, Berkeley and Los Angeles 1964, entry 1081, July 1918, p.374.

[11] For the revision of the Diaries see Christian Geelhaar, 'Journal intime oder Autobiographie? Über Paul Klees Tagebücher', in Armin Zweite (ed.), *Paul Klee: Das Frühwerk 1883–1922*, Munich 1979, pp.246–60.

[12] Kandinsky, *Concerning the Spiritual in Art*, trans. Michael T. H. Sadler, 1914, reprinted with original correspondence, ed. Adrian Glew, London 2006.

[13] Werckmeister 1984, pp.210–12.

[14] *The Creator*, 1934, 213, Zentrum Paul Klee, Bern. See entry no.285, 27 October 1901, *The Diaries of Paul Klee*, 1964, p.66.

[15] 'Über die moderne Kunst', Kunstverein, Jena, 26 January 1924, translated as *On Modern Art*, introd. Herbert Read, trans. Paul Finlay, London 1948, 1967.

[16] Ibid., p.13.

[17] Ibid., pp.21–9.

[18] Ibid., p.45.

[19] Ibid.

[20] Ibid., p.53.

[21] Ibid., p.55.

[22] *Pädagogisches Skizzenbuch*, Dessau 1925, as *Pedagogical Sketchbook*, trans. Sibyl Moholy-Nagy, London 1953, 1968.

[23] Ibid., p.16.

[24] Ibid., p.54.

[25] See *Meister Klee*, Zentrum Paul Klee, Bern 2012.

[26] The insistence on lower-case typography was part of the move towards functionalism.

[27] Spiller noted several manuscript 'deviations from the printed version' in footnotes; see Spiller p.69.

[28] See Klee to Gropius, September 1927,quoted in Anne Buschhoff, "'Die Bauhausarbeit ist leicht, wenn man nicht als Maler sich verpflichtet fuehlt, etwas zu producieren.' Paul Klee als Lehrer am Bauhaus" in Wulf Herzogenrath, Anne Buschhoff and Andreas Vowinckel, eds. *Paul Klee. Lehrer am Bauhaus*, exh. cat., Kunsthalle Bremen 2003, p.20.

[29] Ernö Kállai, 'Vision und Formgesetz', Ferdinand Möller Gallery, Berlin 1930, as 'Vision and the Law of Form', trans. Steven Lindberg, in Timothy O. Benson and Eva Forgács, *Between Worlds: A Sourcebook of Central European Avant-Gardes*, 1910–1930, Cambridge Mass. and London 2002, p.722.

[30] Sibyl Moholy-Nagy, 'Introduction', *Pedagogical Sketchbook*, p.7.

Front cover:
Ghost of a Genius (*Gespenst eines Genies*) 1922, 10, Oil-transfer drawing
and watercolour on paper laid on card, 50 x 35.4 cm
Scottish National Gallery of Modern Art, Edinburgh

Frontispiece:
Comedy (*Komödie*) 1921, 108, Watercolour and oil-transfer drawing on
paper, 30.5 x 45.4 cm, Tate. Purchased 1946

'Creative Confession'
Paul Klee, Creative Credo, in *The Inward Vision: Watercolors,
Drawings, Writings*. Translated from the German by Norbert Guterman,
Thames & Hudson, London [c.1958], pp.5–10.
By kind permission of Thames & Hudson

'Ways of Nature Study' and 'Exact Experiments in the Realm of Art'
Jürg Spiller ed., *Paul Klee: The Thinking Eye; The Notebooks of Paul Klee*,
vol.1, Basle 1956, translated by Ralph Manheim with Charlotte Weidler and
Joyce Wittenborn, London and New York 1961, pp.63–7 and pp.69-70.
By kind permission of Ashgate, Gower and Lund Humphries Publishing

I should like to thank the editors who have looked after this small book,
Nicola Bion, Rebecca Fortey and Beth Thomas, as well as the designers,
Inventory Studio London, who have seen it through to production.

MG